Hall of opulence and mirrors
Versailles, France (opposite page)

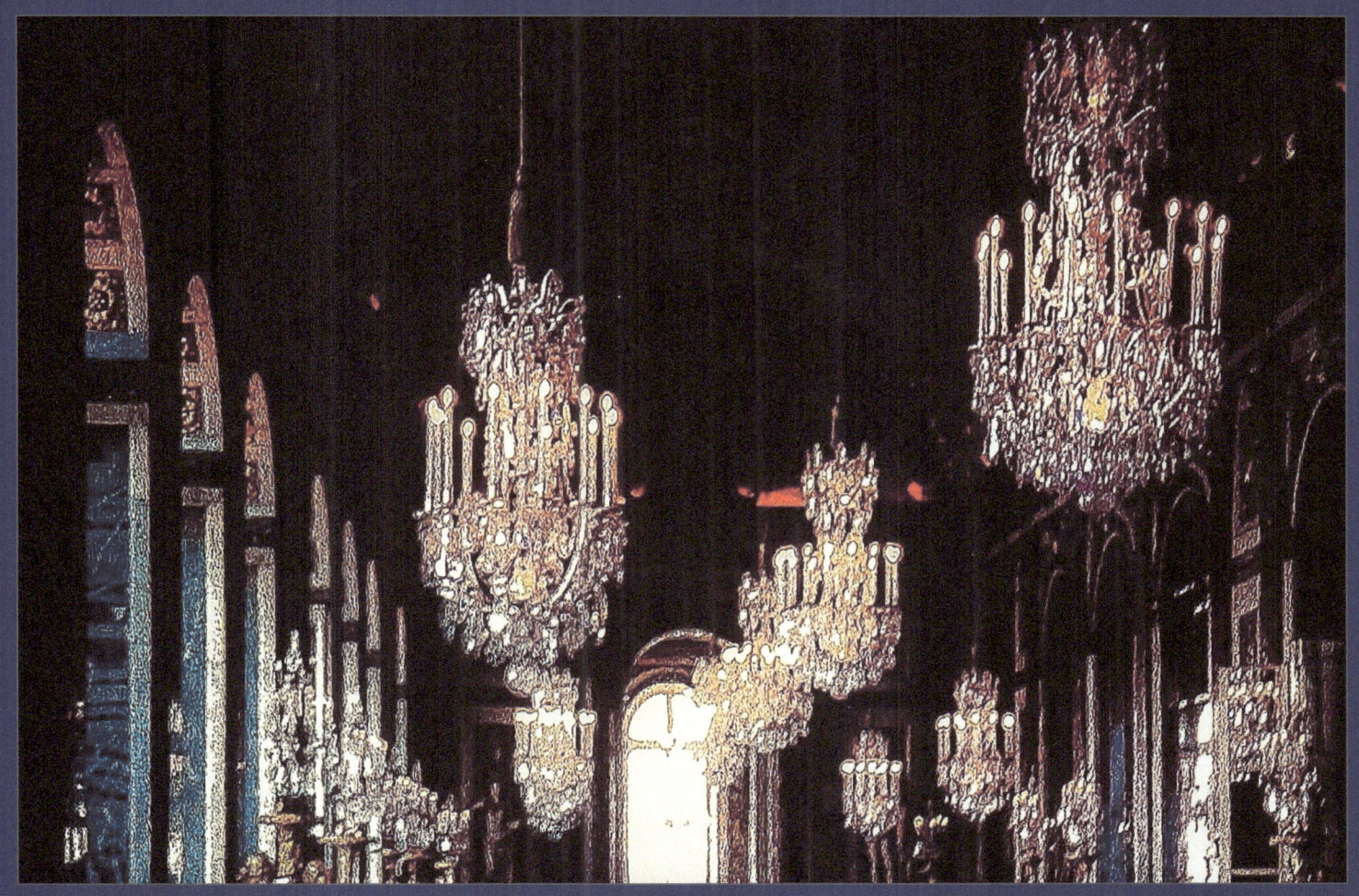

Images from Atwood

Chandeliers and Round Things

Chandeliers and Round Things

Images from Atwood

For artisans and friends

Copyright 2016, Echo Hill Arts Press, LLC
All rights reserved, including the right to
reproduce any part of this book.
ISBN: 13-978-1534960428
Colorado Springs, CO, USA

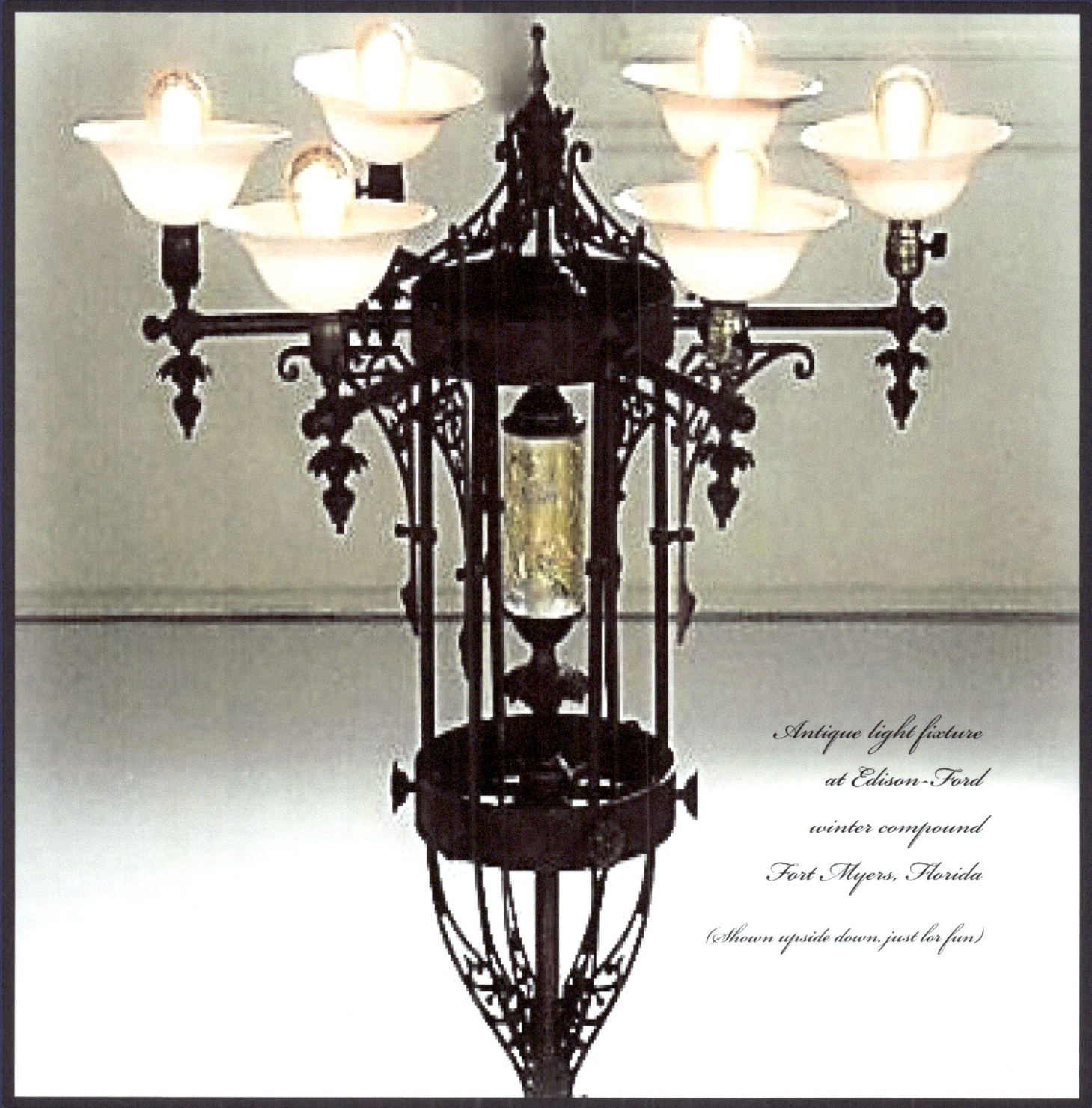

Antique light fixture at Edison-Ford winter compound Fort Myers, Florida (Shown upside down, just for fun)

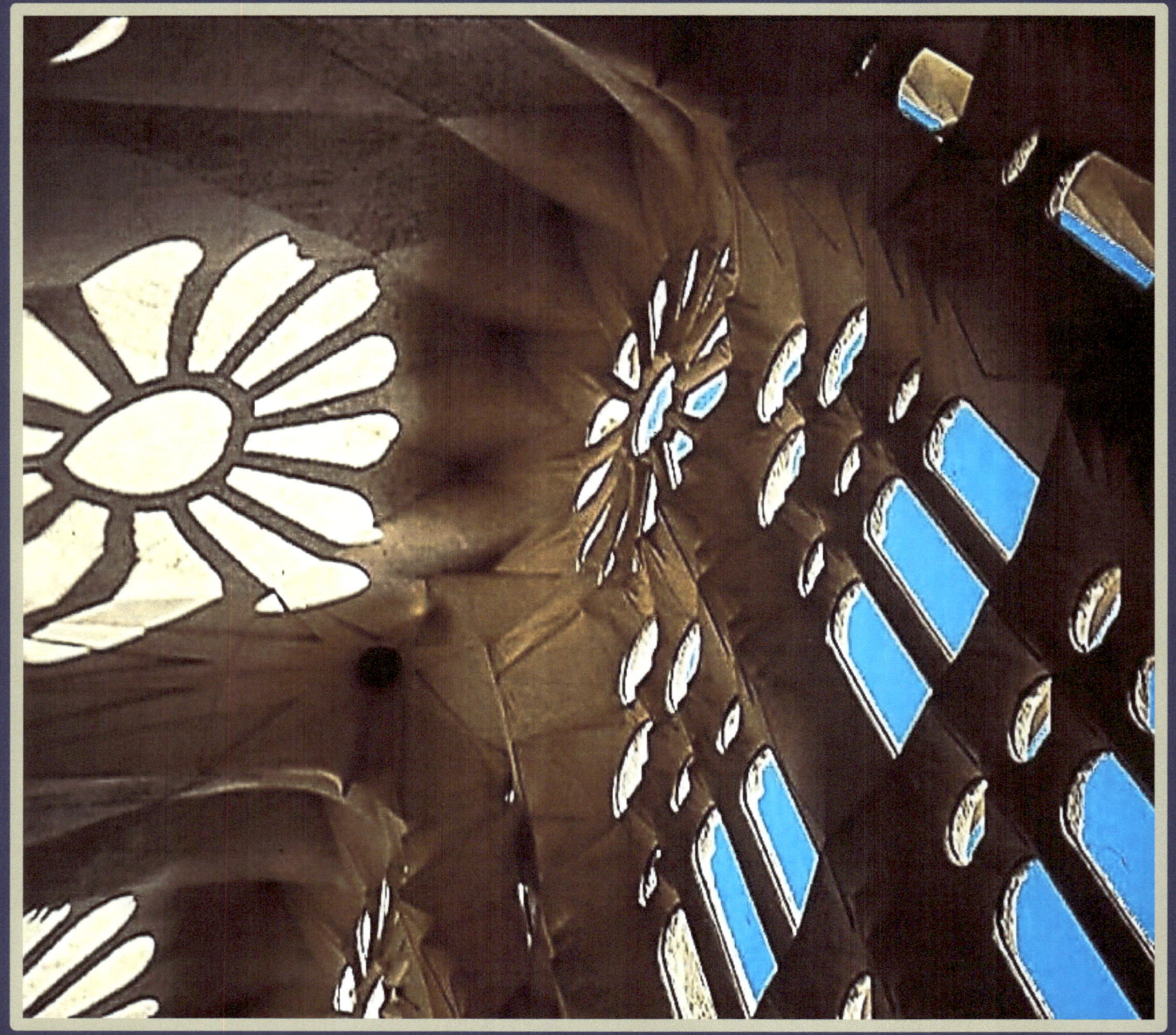

Unfinished Sagrada Familia Barcelona, Spain

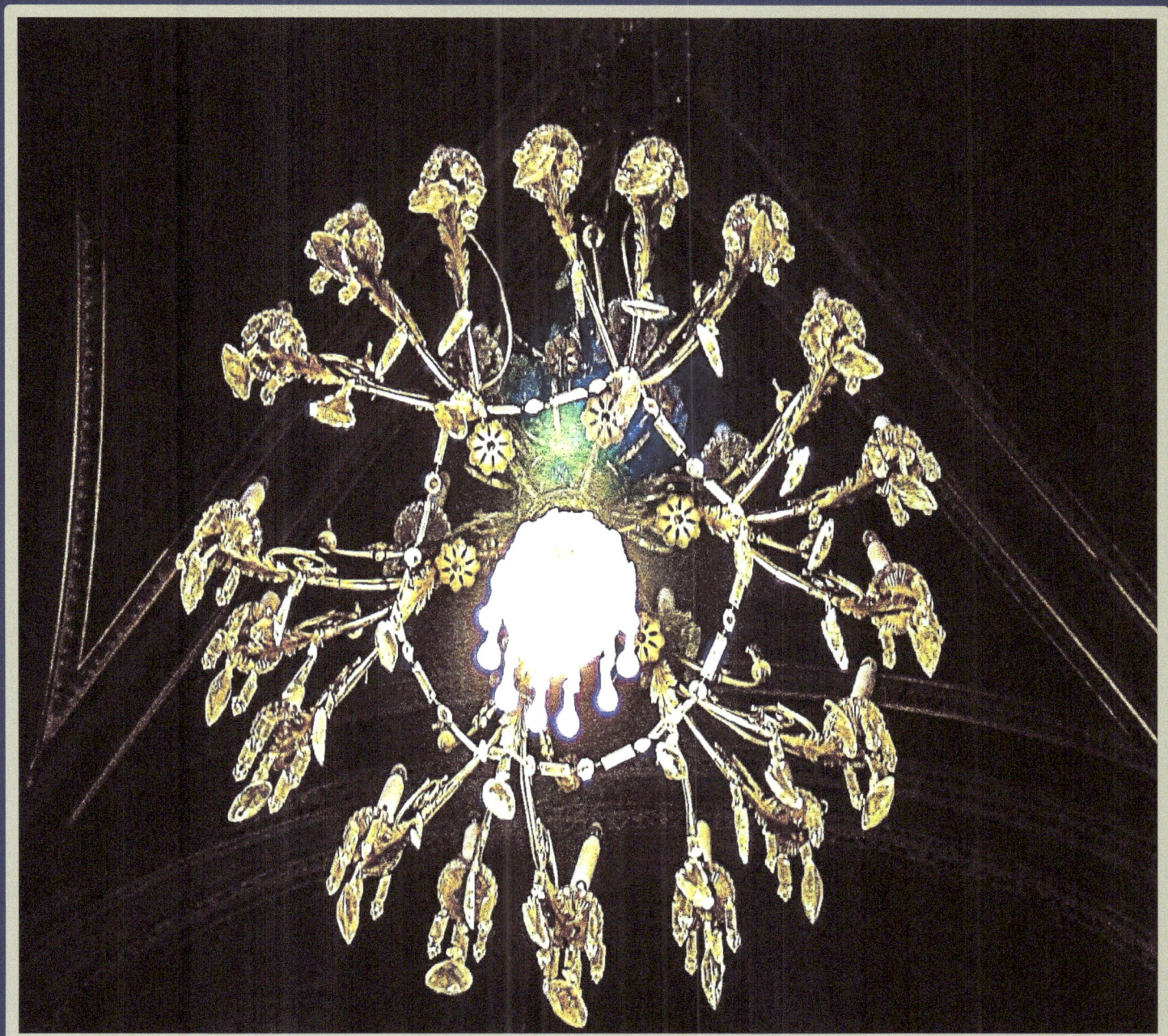

Rarified ceiling

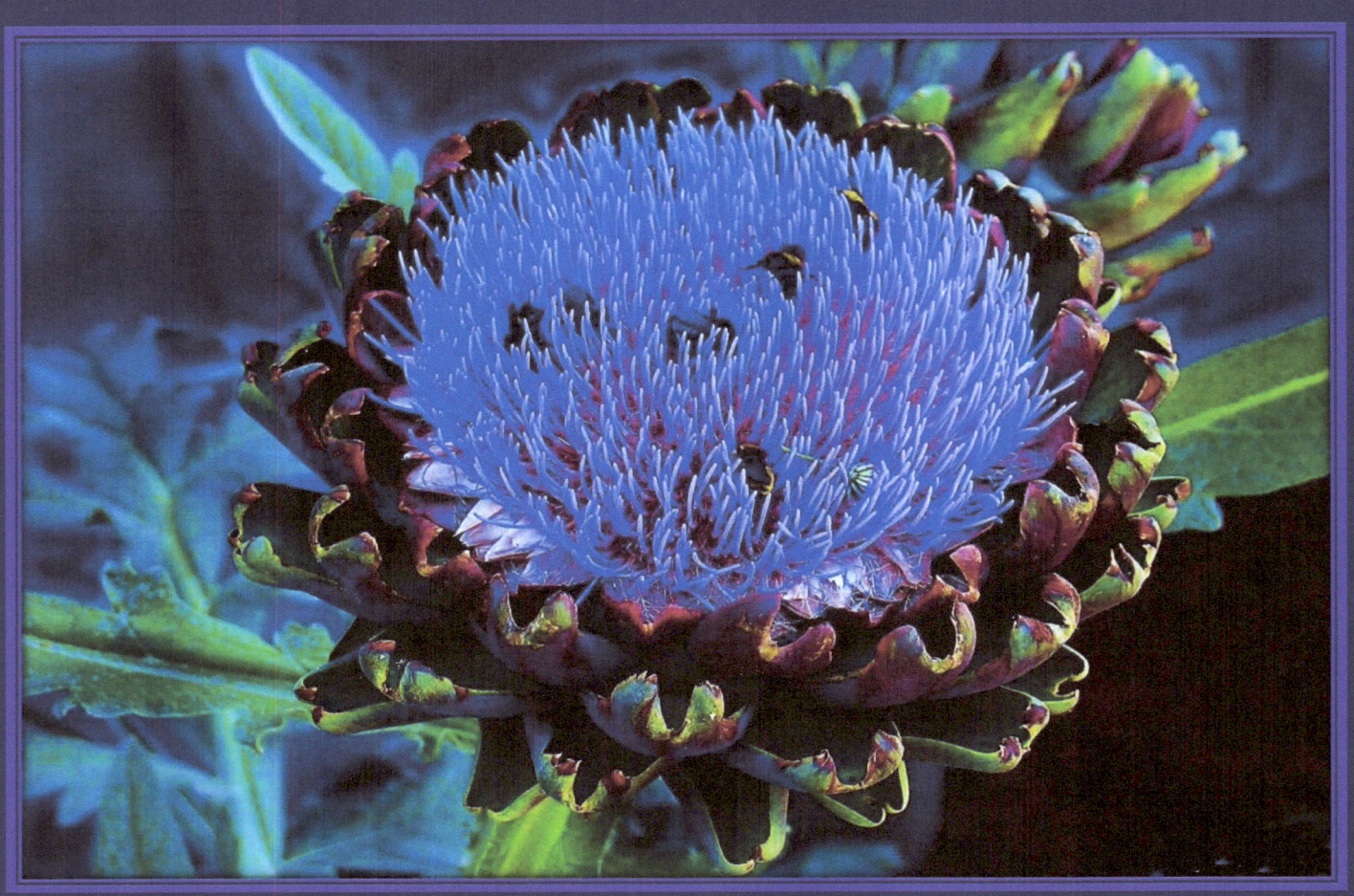

Artichoke flower with bees

Notre Dame, Paris France

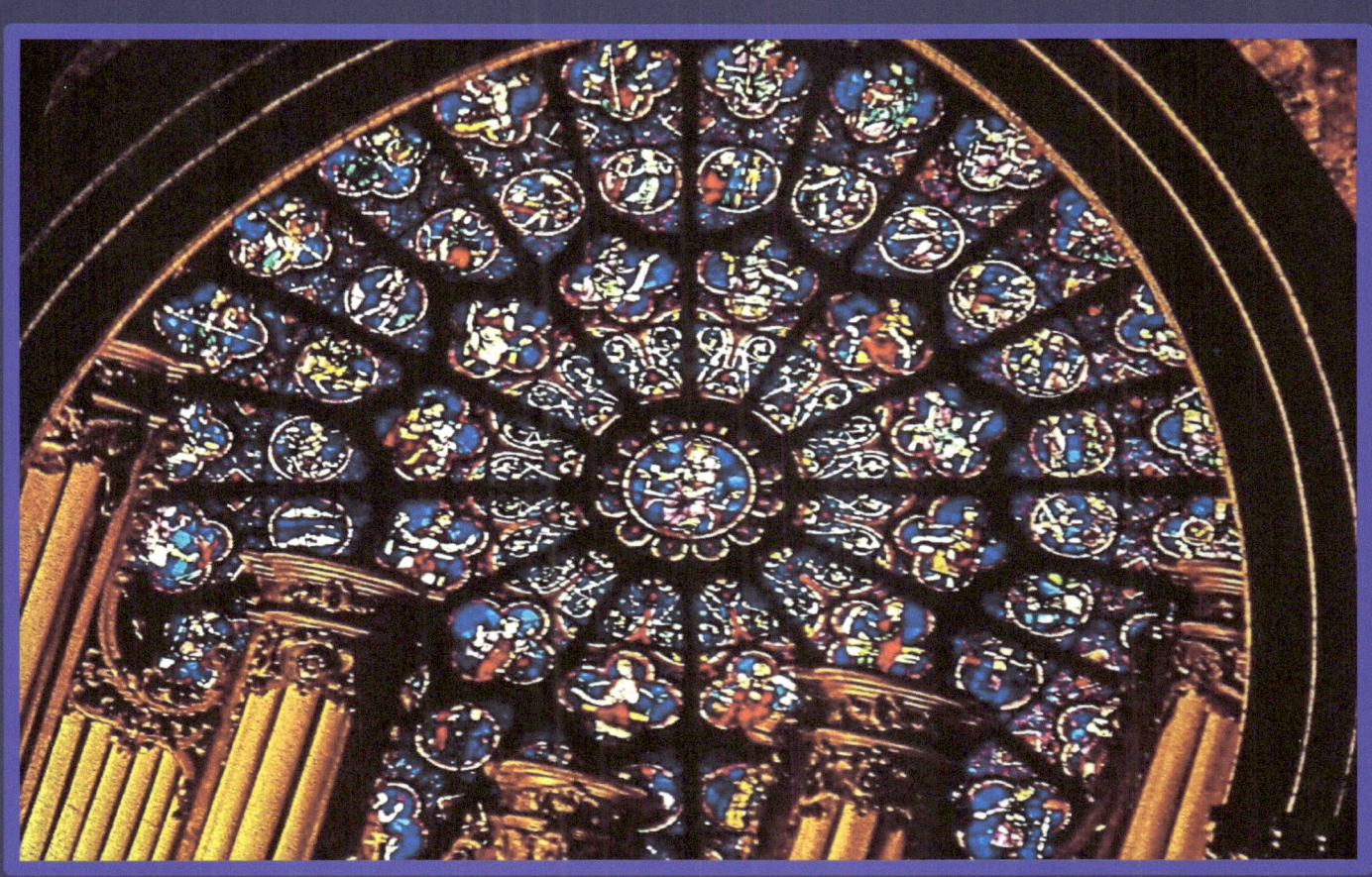

Apricot salad and hummus

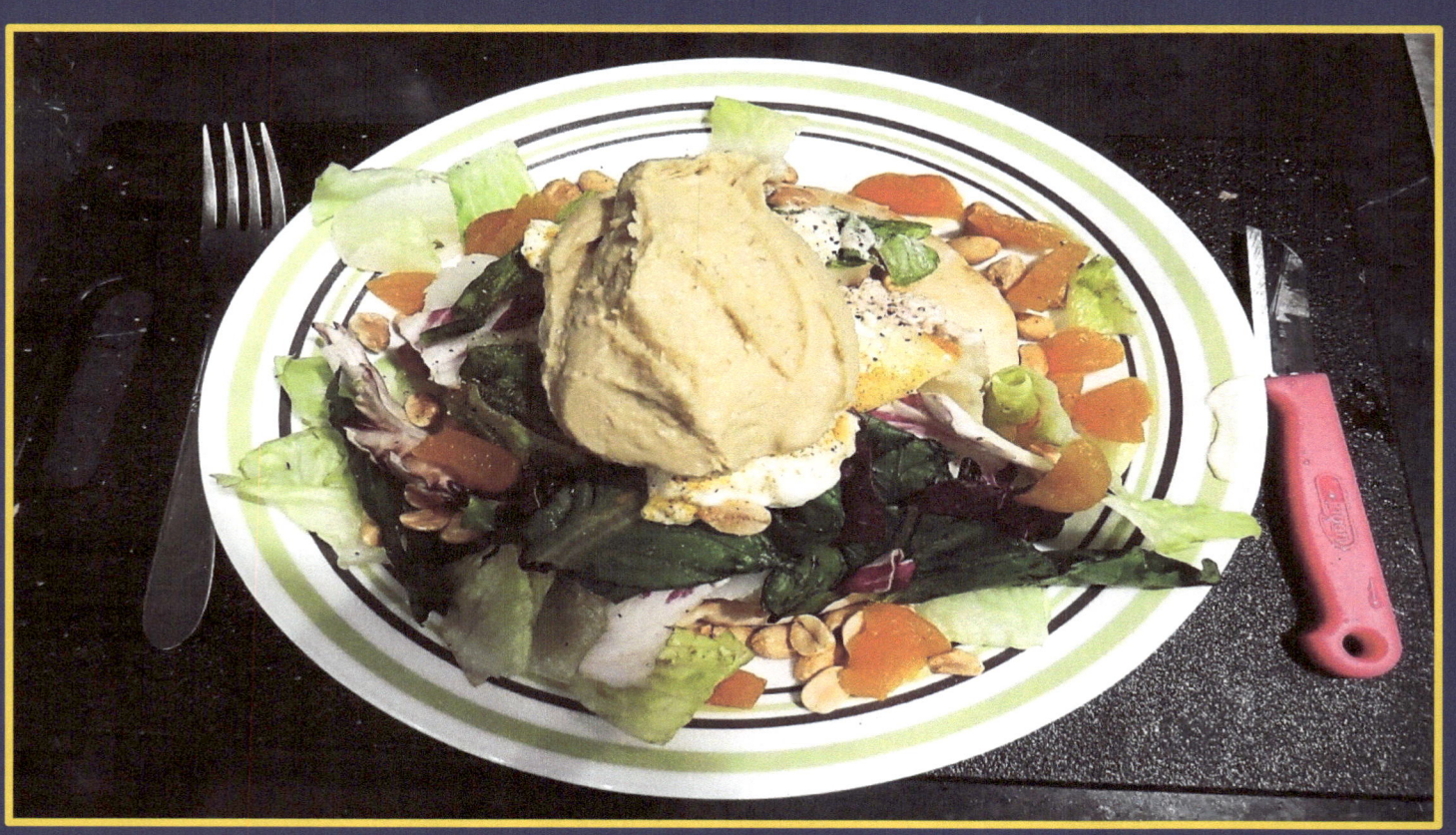

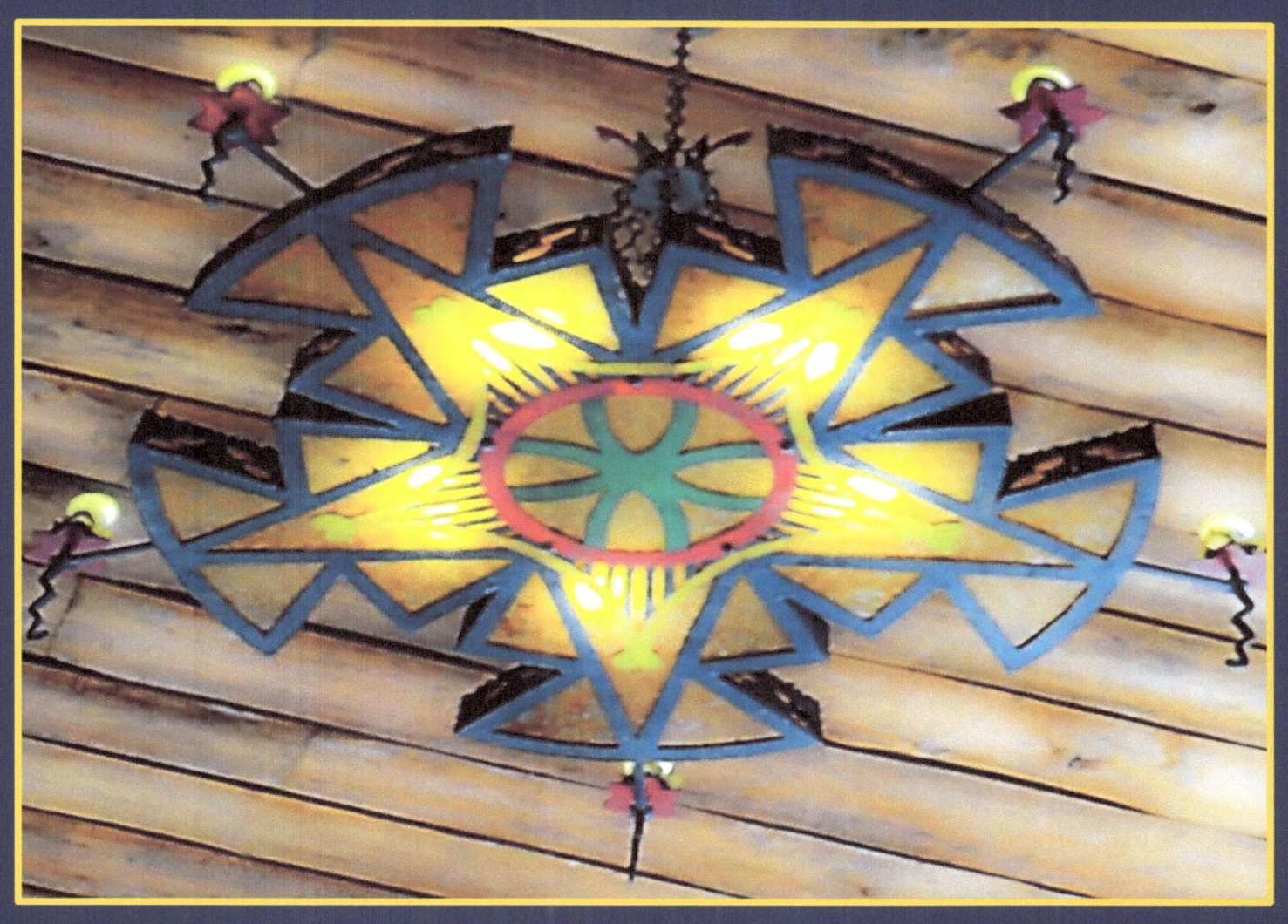

Ceiling chandelier in the main lodge, Grand Canyon, North Rim

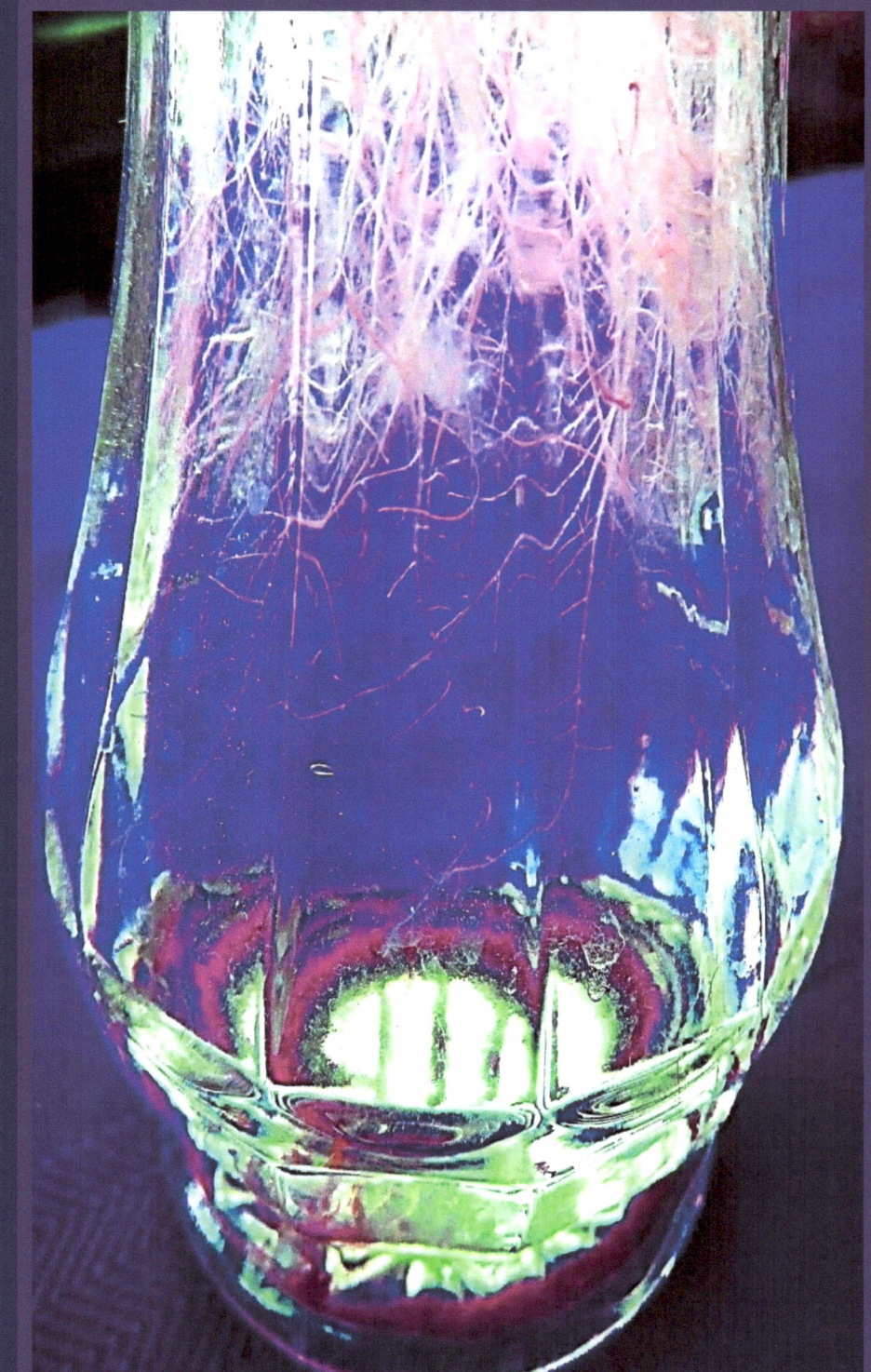

Water garden one

Water garden two

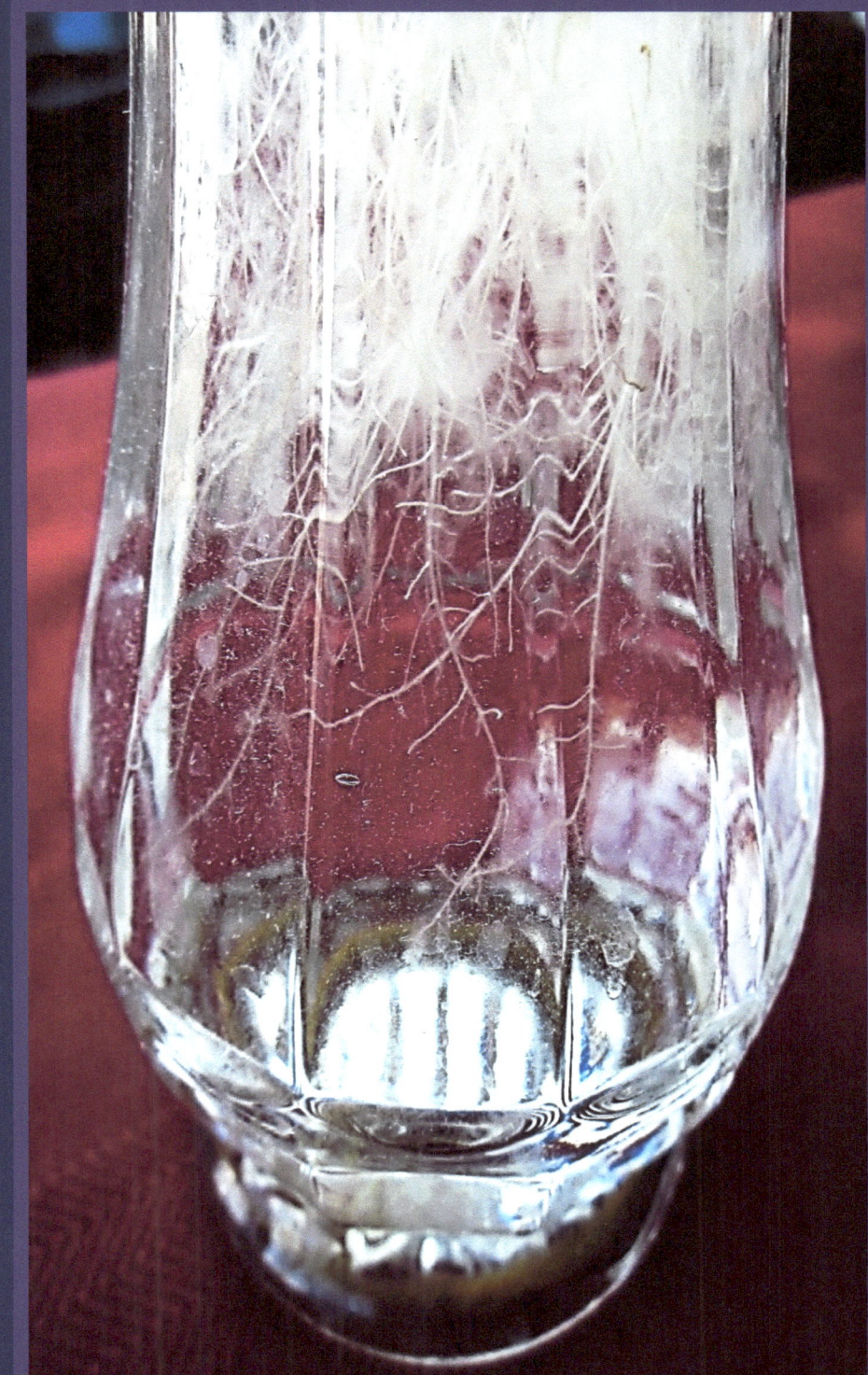

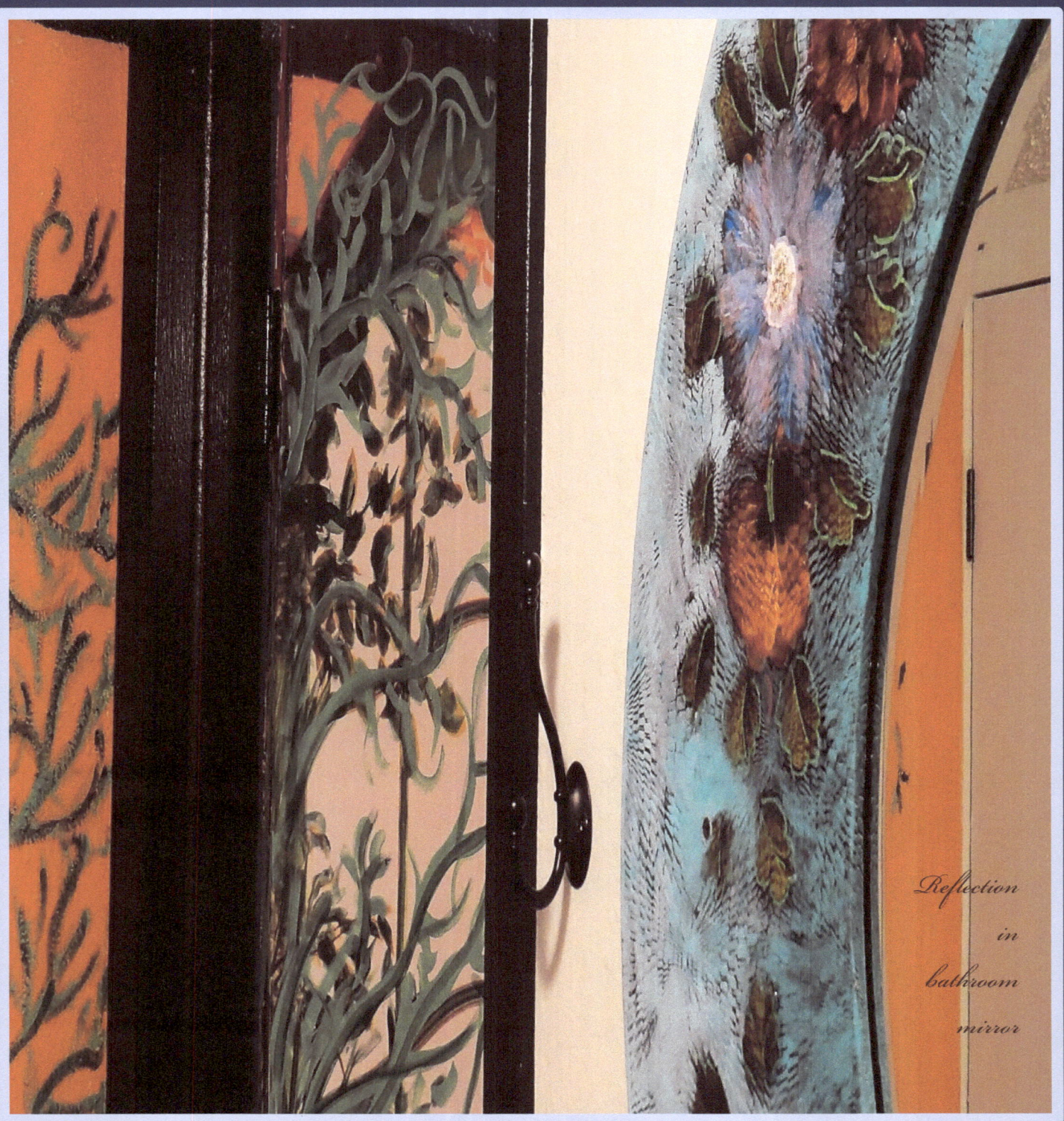

Reflection in bathroom mirror

Oil drop on a wet road

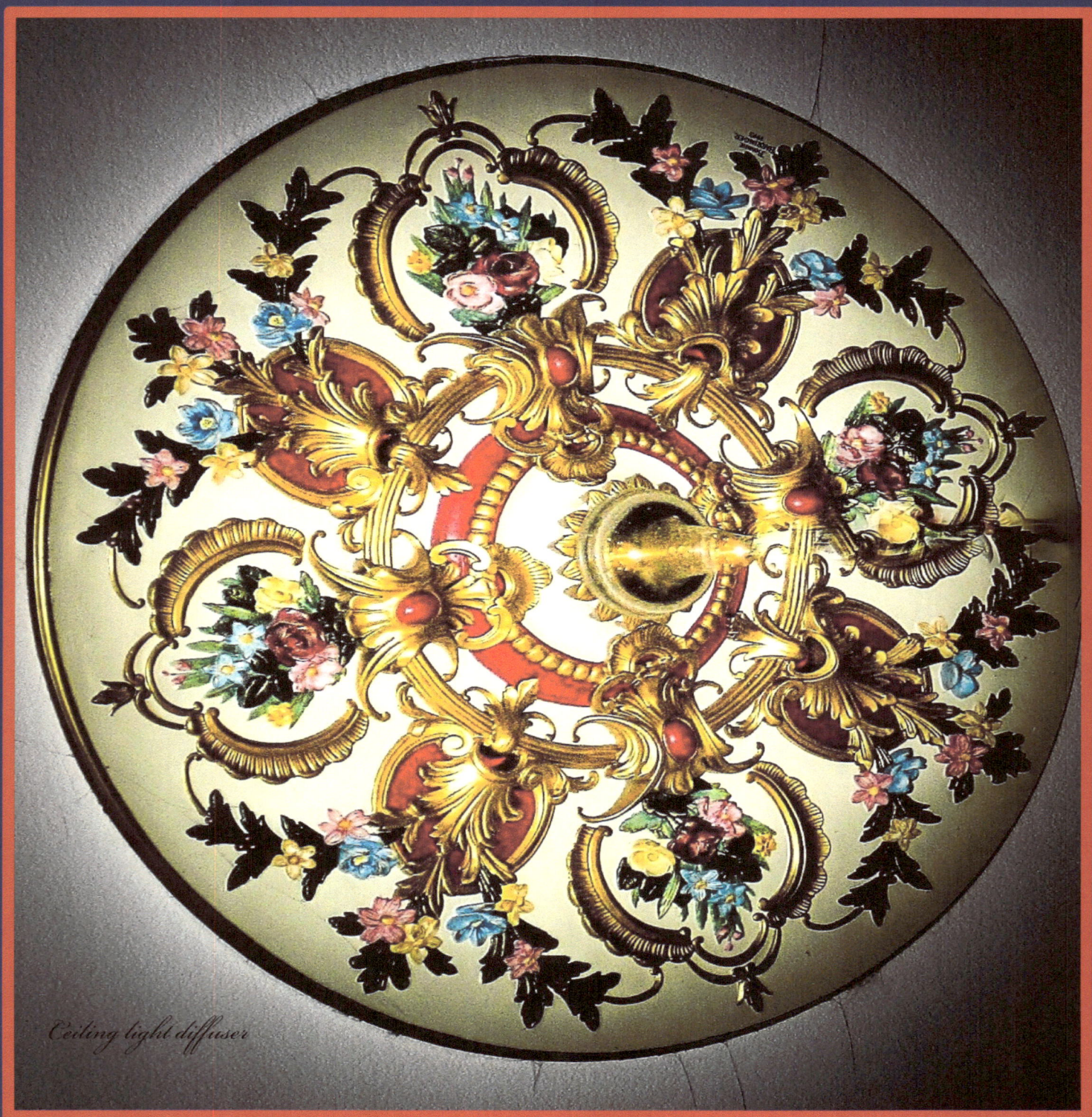
Ceiling light diffuser

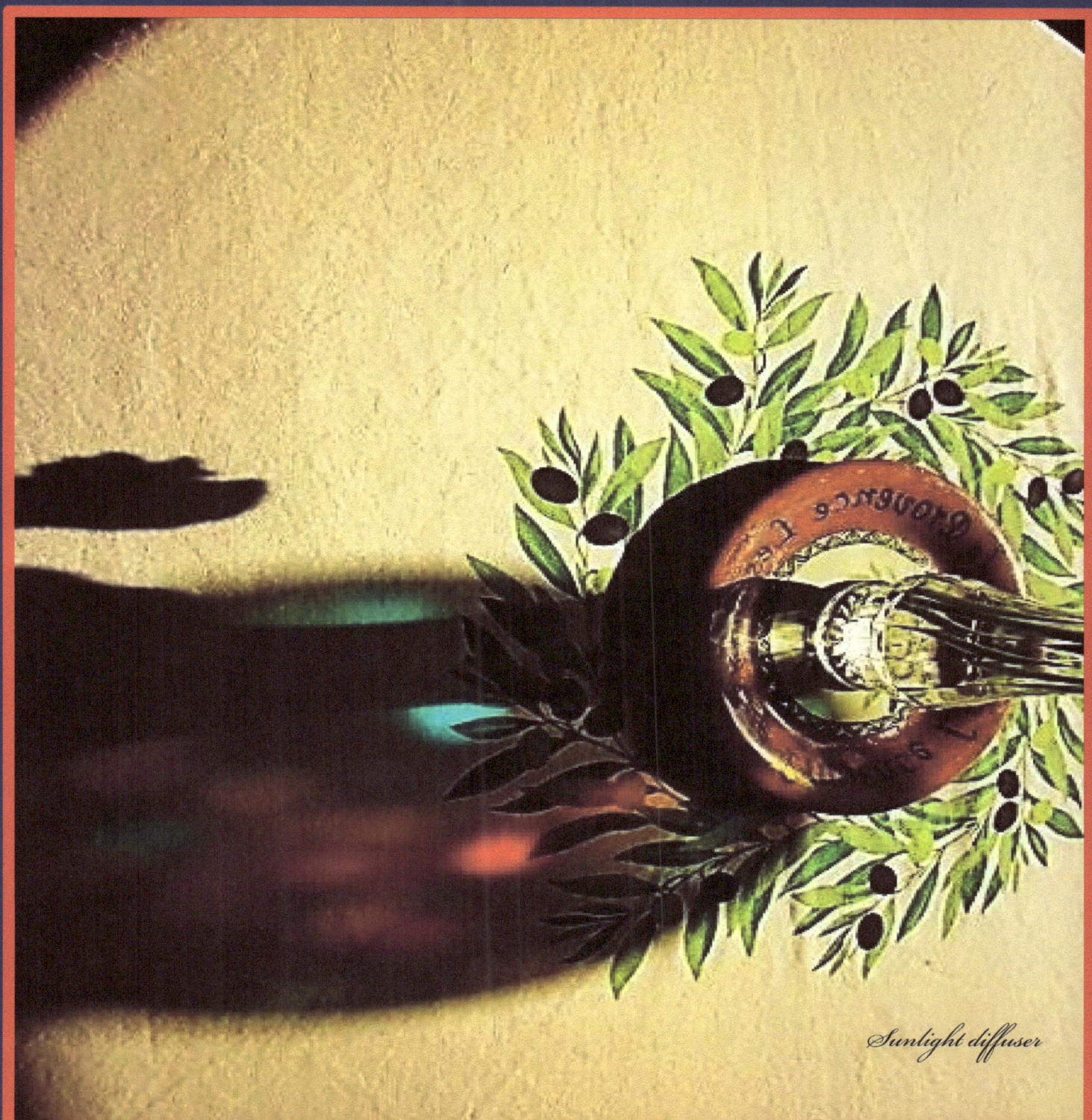

Sunlight diffuser

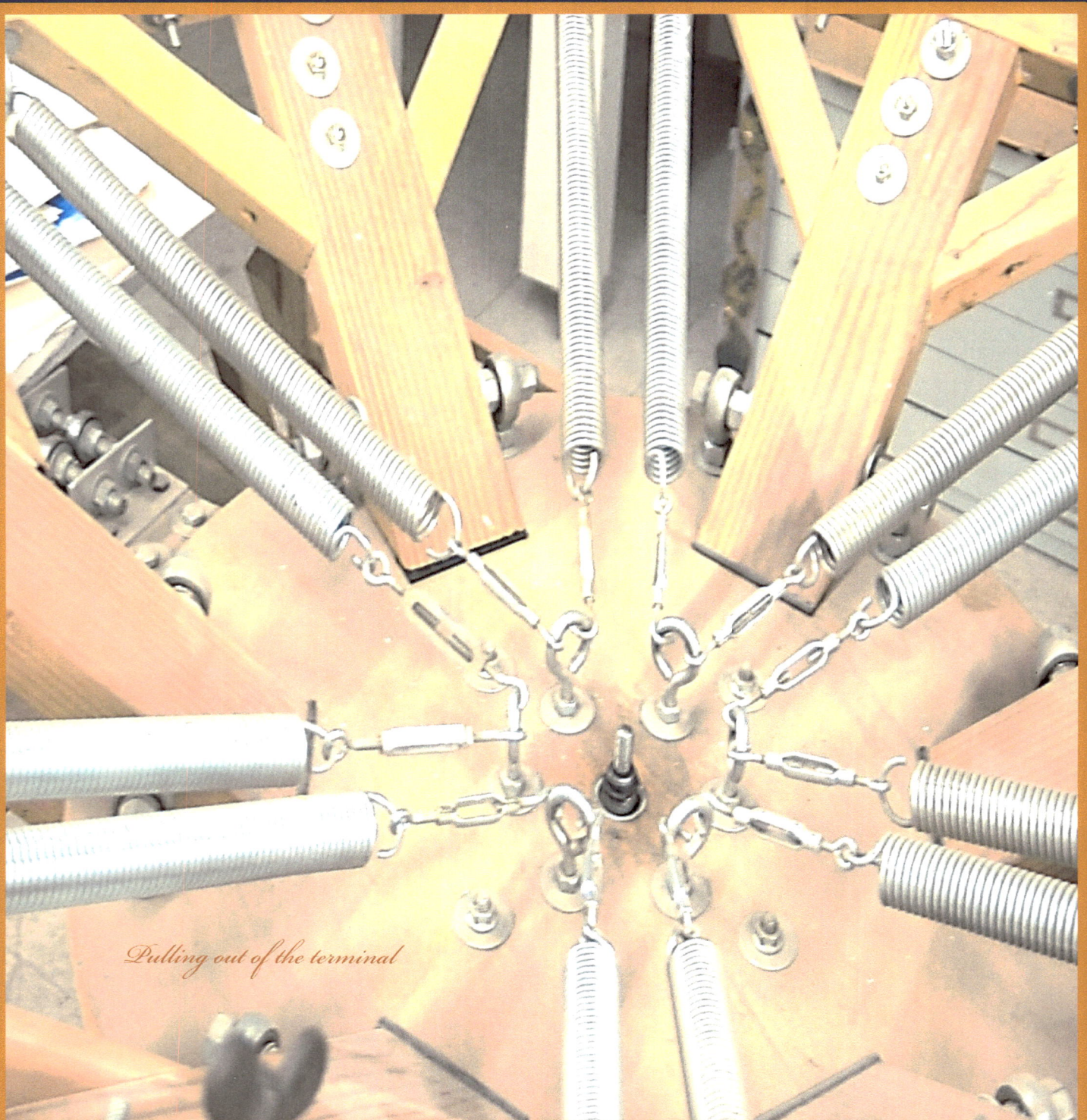
Pulling out of the terminal

All aglow in the night

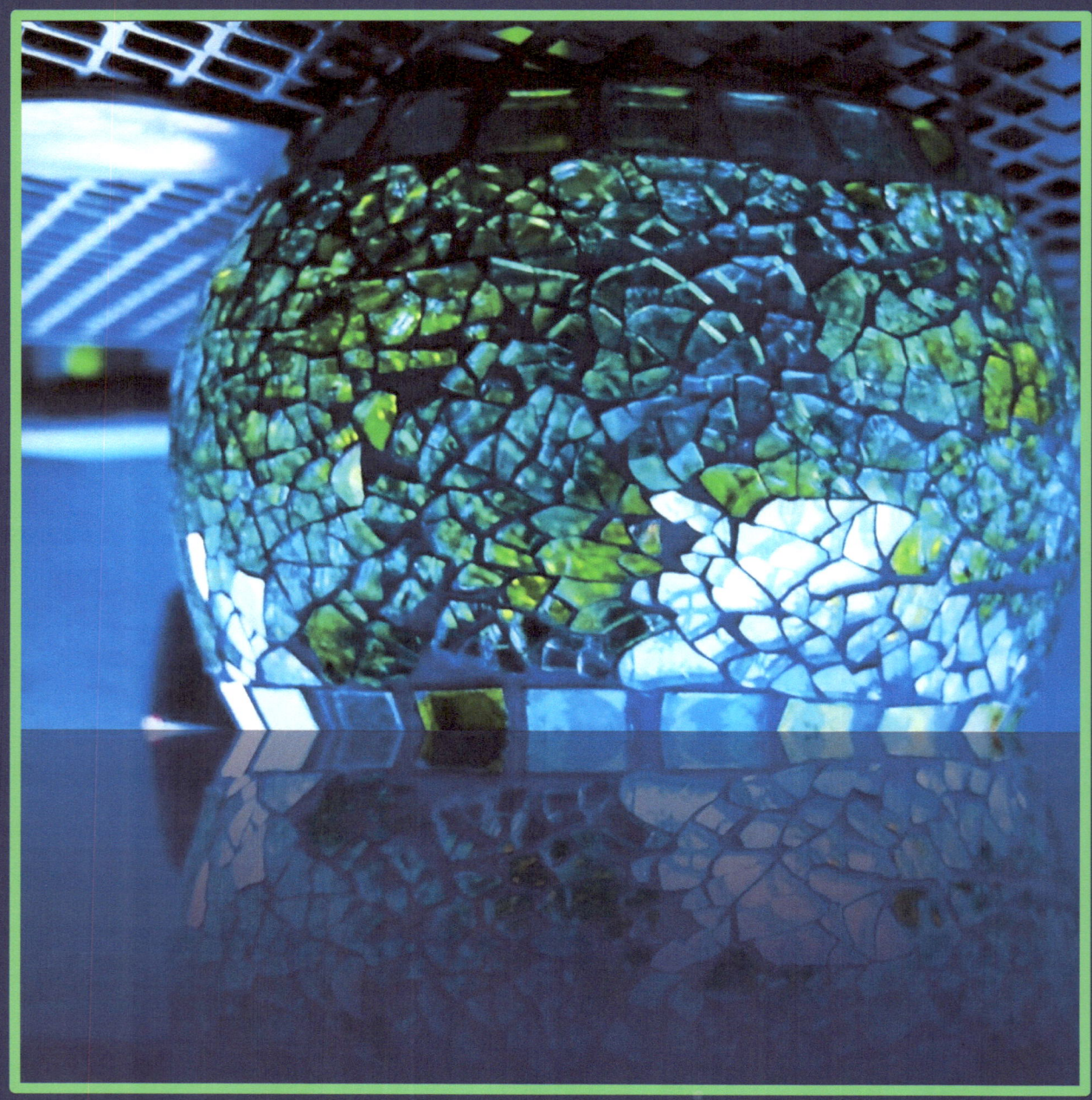

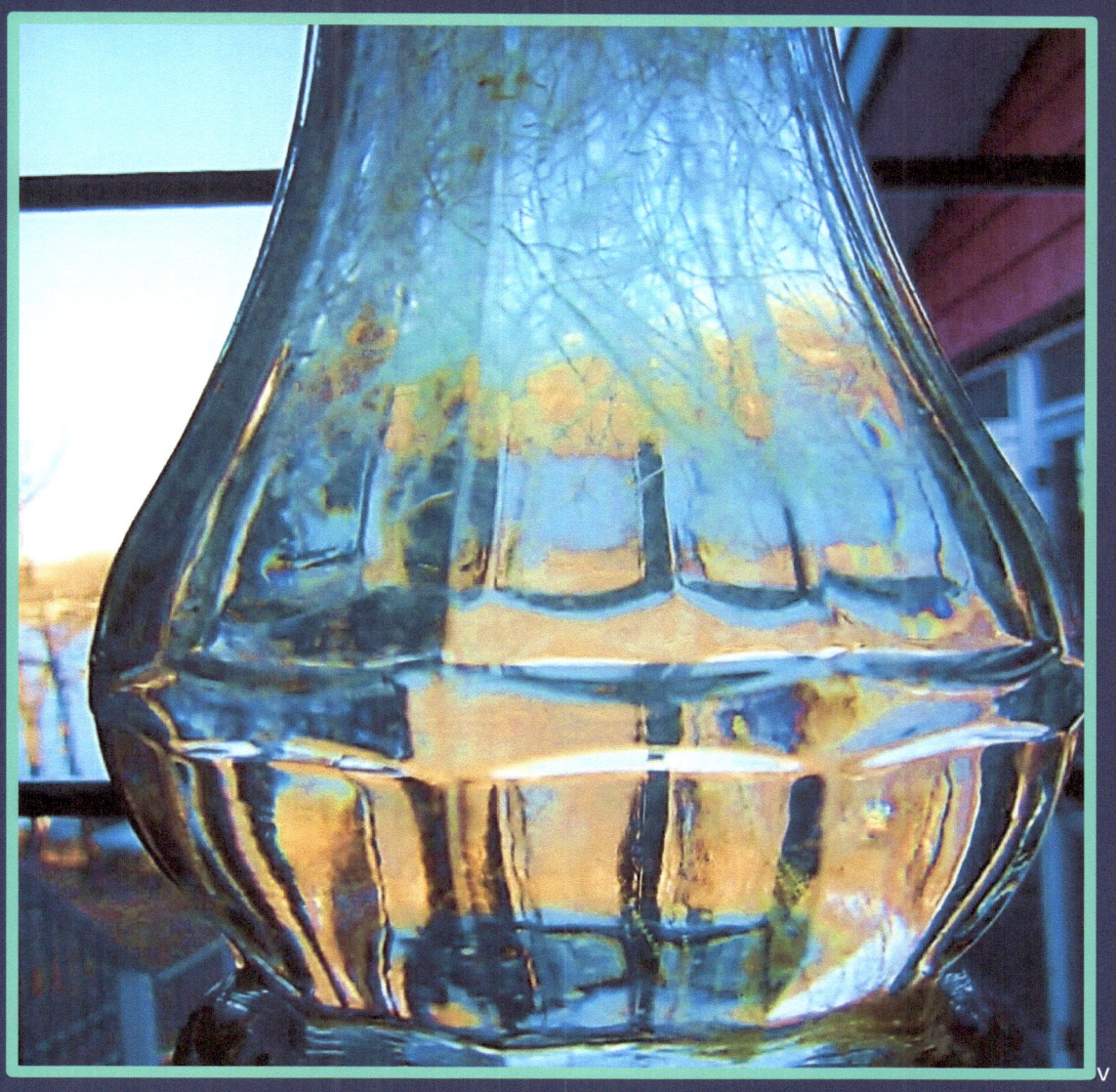

Miniature tree-scape

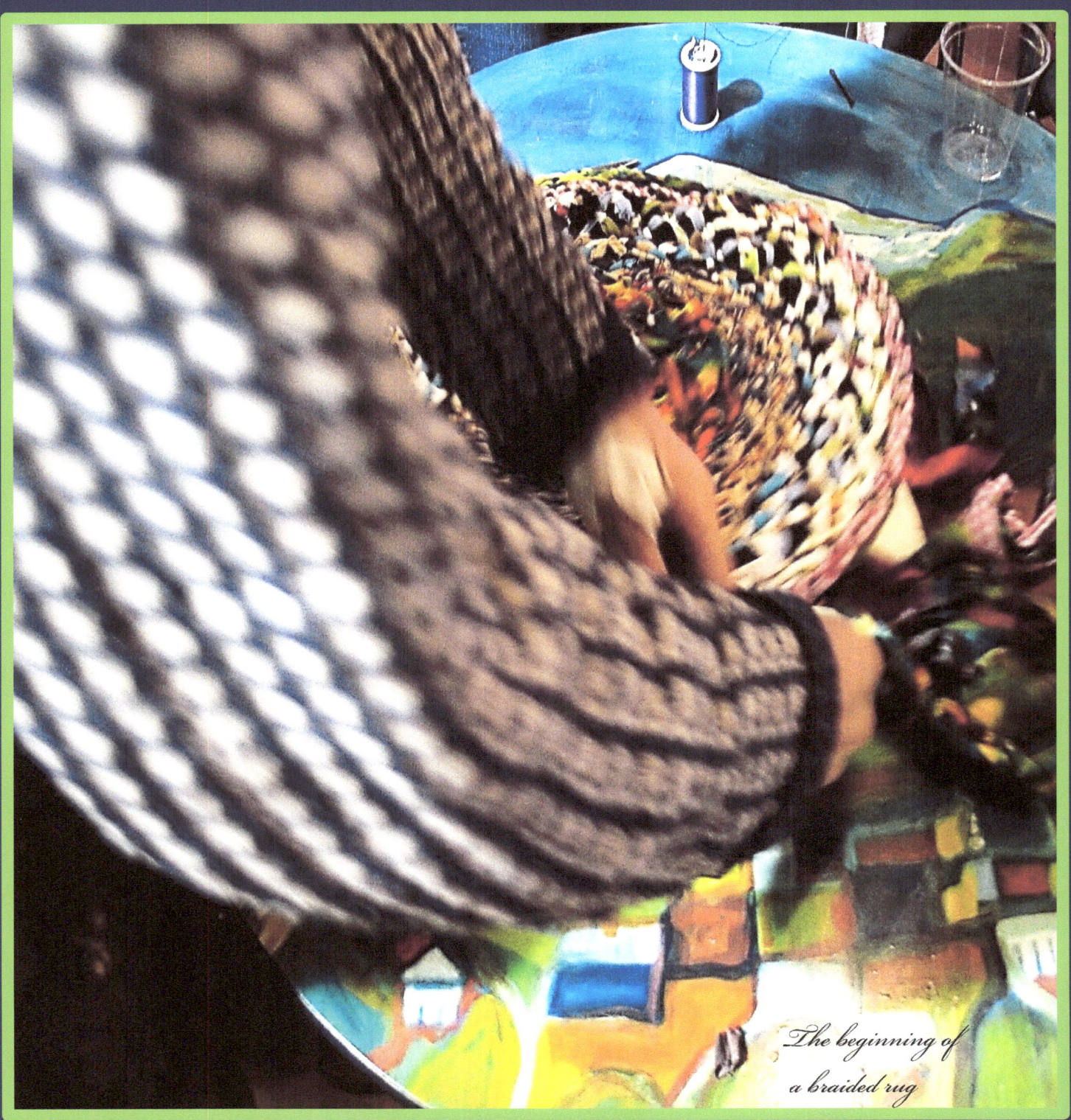

The beginning of a braided rug

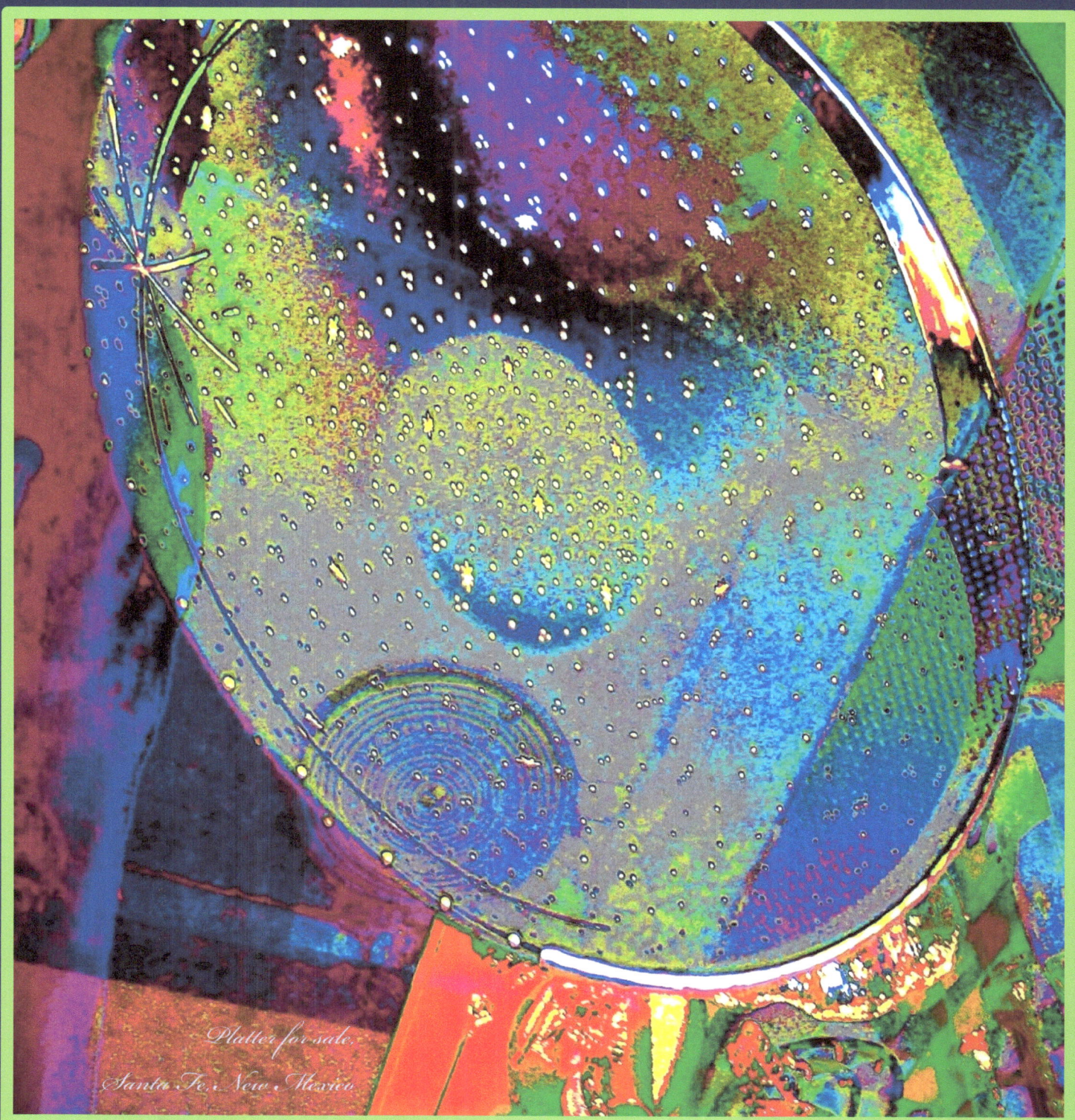

Platter for sale, Santa Fe, New Mexico

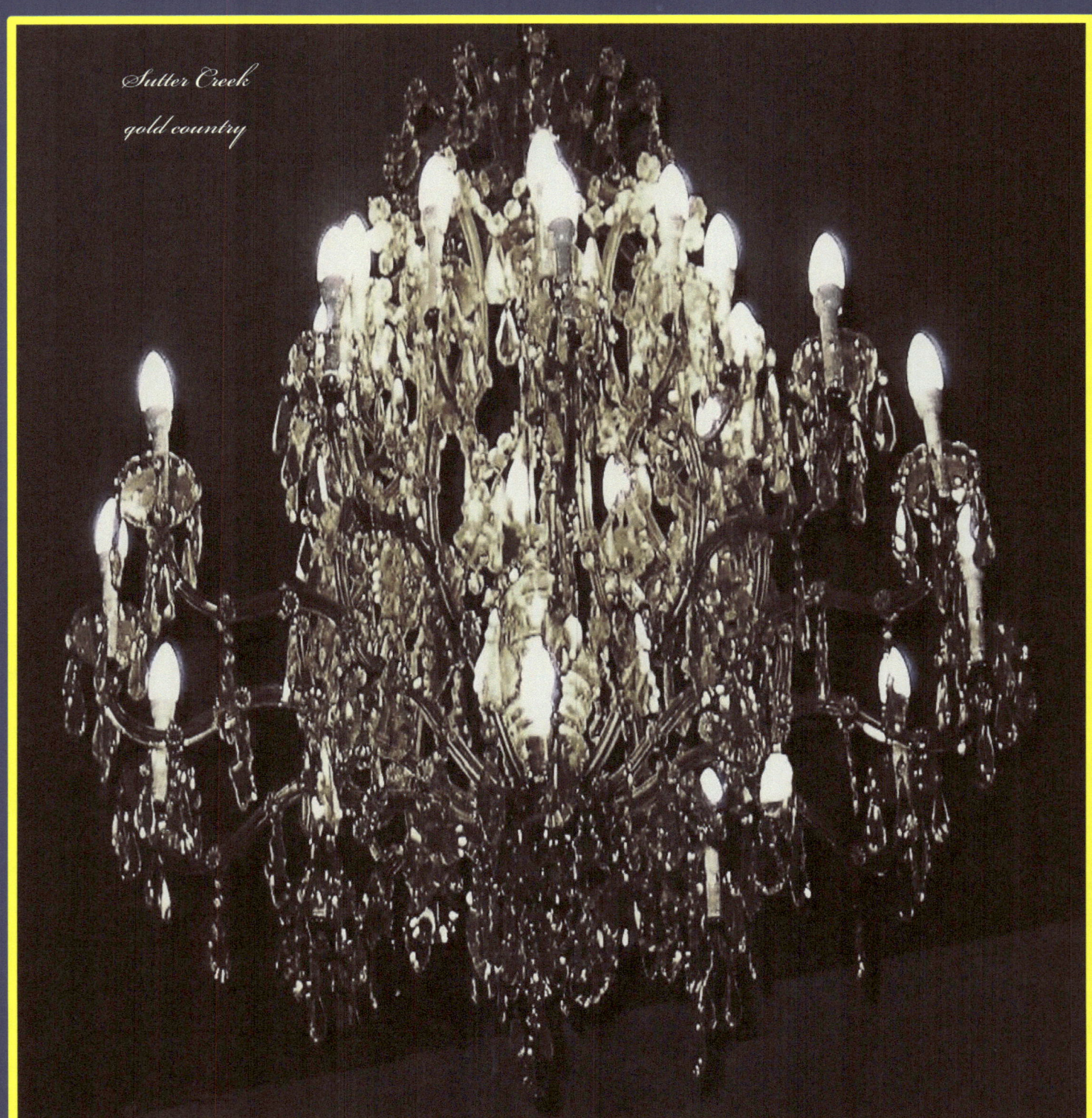

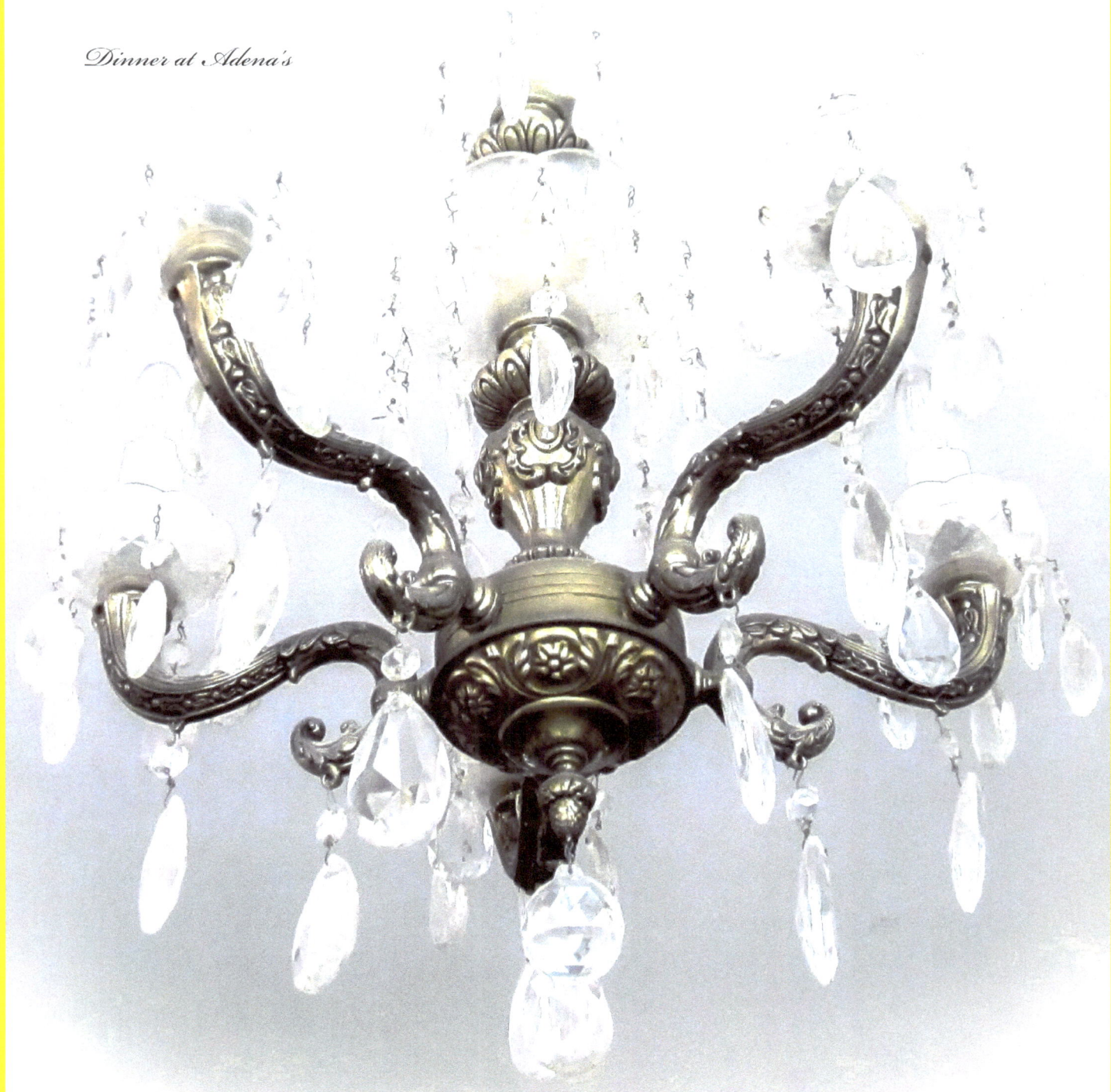

Dinner at Adena's

Echo Hill Arts
is pleased to make a new line of
Images from Atwood
Photographic Diversions for Areas of Waiting

available Print on Demand
through **Amazon.com** *and* **CreateSpace Direct**

Echo Hill Arts Press